THE FOUR SEASONS
FALL

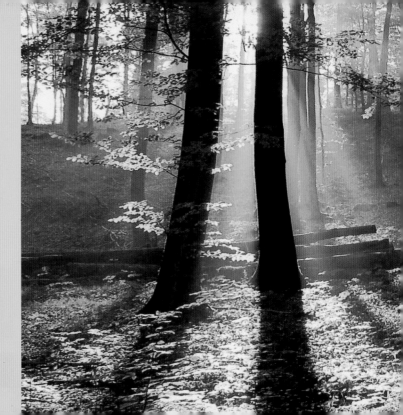

Focal Press is an imprint of Elsevier Inc.
225 Wyman Street, Waltham
MA 02451, USA

This book was conceived, designed, and produced by
Ilex Press Limited, 210 High Street, Lewes, BN7 2NS, UK

PUBLISHER: Alastair Campbell
CREATIVE DIRECTOR: Peter Bridgewater
ASSOCIATE PUBLISHER: Adam Juniper
MANAGING EDITOR: Natalia Price-Cabrera and Zara Larcombe
EDITORIAL ASSISTANT: Tara Gallagher
ART DIRECTOR: James Hollywell
DESIGNER: Ginny Zeal
COLOR ORIGINATION: Ivy Press Reprographics

Library of Congress Control Number:
A catalog record for this book is available from the Library of Congress.

SET:
ISBN: 978-0-240817-85-9
INDIVIDUAL BOOK:
ISBN: 978-0-240820-41-5

For information on all Focal Press publications visit our website at:
www.focalpress.com

Printed and bound in China

10 11 12 13 14 5 4 3 2 1

CONTENTS

 # INTRODUCTION

WHAT MAKES THIS SEASON SPECIAL? It's a simple question that all landscape photographers should ask themselves, but in fall the answer is relatively straightforward: color. Although every season marks a change in the natural world, fall is perhaps the most visibly obvious, as the lush greens of summer give way to barren winter landscapes in a fanfare of color. As the leaves triumphantly die, fall is a brash season—in your face, and impossible to ignore. Even in the city there will be trees that burn brightly among their concrete, steel, and glass surroundings, leaving you with no doubt that summer has passed and winter's bite approaches. And it all screams out to be photographed.

Yet at the same time, it's important to realize that fall—like any season—is transitional. The intense reds, oranges, and golds may transform the landscape as deciduous trees prepare to shed their leaves, but this rarely happens overnight. As the change is gradual, fall photography shouldn't just be considered a one-time exercise, but approached as a continual study: a series of images taken from the same viewpoint, maybe a week apart, can document this particularly well.

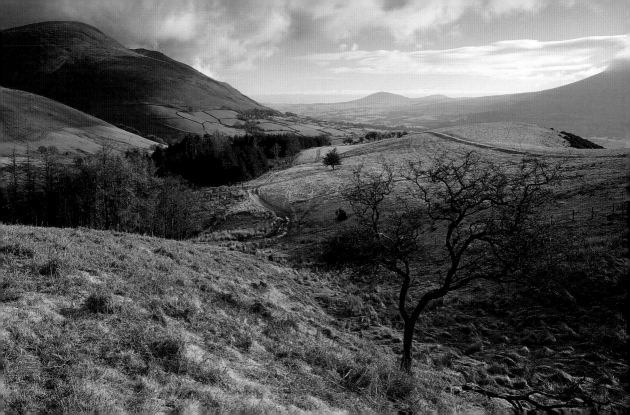

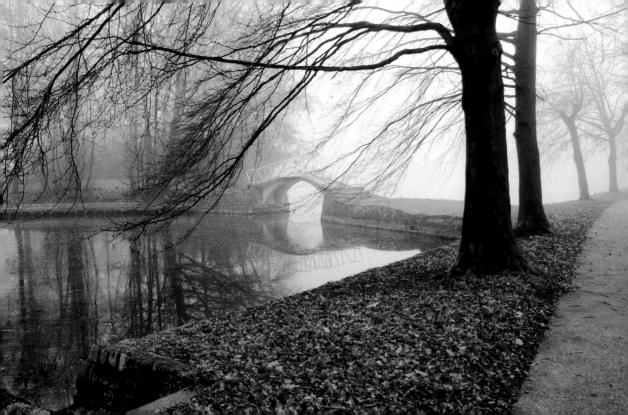

However, the turning leaves are just one aspect to the season, and color isn't the sole reason why you should pick up your camera and head outdoors.

As the temperature turns from warm to cold—perhaps in the space of just a few days—there is every possibility that your sorties into the landscape will be met by ever-changing weather. Early morning is a time when the conditions can vary wildly, with low-lying mist, thick fog, and frost all possible. Rain, too, is never that far away in more northerly U.S. and European regions and, while many of these conditions may make you think that staying indoors in the warm is the best option, don't! Sure, rain and fog aren't usually considered the ideal conditions for photography, and might hamper your efforts, particularly if you have a preconceived idea about what it is you want to achieve. But that doesn't mean that they make it impossible to take pictures. Fall has something to offer photographers regardless of the weather conditions. If you can keep an open mind about the subjects you photograph—as well as an open creative eye for spotting their potential—you should return home with some stunning images.

ESSENTIALS

FALL CAMERA KIT

TO MAKE THE MOST of your photography in fall, there are a number of items you should be sure to pack in your kit bag:

MACRO LENS
Ideal for getting close to frost-encrusted leaves and fungi for frame-filling fall details.

TELEPHOTO ZOOM
A fast zoom with a long focal length is perfect for compressing distant trees and accentuating their blaze of color. It's also great for getting closer to wildlife.

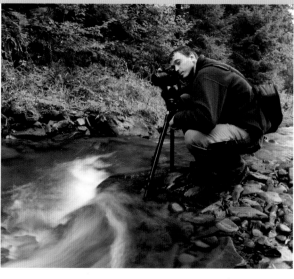

TRIPOD
A tripod that drops to ground level will help you capture low-level subjects or shoot from more interesting angles. It will also offer general stability for more distant landscapes.

WHITE BALANCE DISC

Fits over your lens to simplify setting a custom white balance for those perfect fall colors. Some manufacturers also offer a "warm white" option that is perfect for enhancing naturally warm colors. Picture courtesy of Expodisc.

POLARIZING FILTER

For reducing reflections and enhancing color, see pages 12–15.

NEUTRAL DENSITY FILTER

For extending shutter speeds with watery subjects or using a wider aperture to pick out details, see pages 16–19.

WATERPROOF CAMERA CAPE

Protects your camera from the damp if you're shooting in mist and fog, and won't let a rain shower send you packing. Camouflaged capes will also help break up your shape if you're photographing wildlife, helping prevent you from startling your prey. Picture courtesy of Kata.

FILTERS

ALTHOUGH LENS-MOUNTED FILTERS have largely been superseded by their digital equivalents, there are two filters that should be considered essential kit-bag additions if you want to make the most of your landscape photography opportunities: a polarizer, and neutral density filters (plain or graduated). A slot-in filter system will provide the greatest versatility if you have several lenses with different filter ring diameters, as you can use the same filters on each of your lenses: you just need an appropriately sized adapter ring, rather than a full set of filters for each lens.

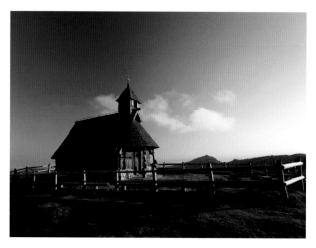

LEFT: In the past, landscape photographers needed to arm themselves with a wide range of creative and technical filters, but these are largely unnecessary for digital photography.

ABOVE: Care needs to be taken when using a polarizer on a wide-angle lens, as the polarization can result in an uneven sky.

POLARIZING FILTER TIPS

Whether you use a screw-fit polarizer on the front of your lens, or attach it using a slot-in filter holder, the effect of a polarizing filter is controlled by rotating the filter, with the greatest polarizing effect achieved when the sun is at a 90-degree angle to the camera.

If you're using a full-frame camera, be aware that using a polarizing filter on a wide-angle lens can lead to vignetting due to deep profile of the filter's rim. If your camera doesn't have a full-frame sensor this isn't going to be a problem, but if it does, you may want to think about investing in a slightly more expensive polarizer with a narrower profile.

Polarizing filters reduce the amount of light reaching the sensor. Depending on the intensity of the polarization, this light loss could be anything up to 2-stops, so if you have any moving elements in your shot, keep an eye on the shutter speed to avoid them blurring.

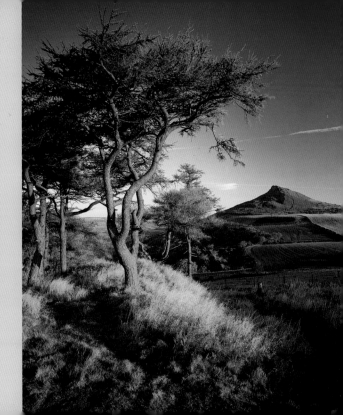

RIGHT: A polarizing filter has several uses, one of which is to intensify color—especially in blue skies.

Polarizing filter

Although a polarizing filter is a year-round landscape essential, it is all the more useful for photographing fall. In addition to its two most obvious properties—darkening skies and reducing reflections on water—a polarizer is also capable of delivering stronger colors. How? Well, the colors of fall leaves are naturally vibrant, but sometimes our eyes can overestimate just how intense that color is. On an overcast day the colors will appear to be richly saturated when they are set against a flat gray sky, but the actual intensity of the color can be diminished if they're wet: the color may appear bold, but the light reflecting from the wet surface will have a desaturating effect. Fitting a polarizing filter and using it to reduce this reflected light will quickly bring the color back, and increase the intensity of your fall shots.

ABOVE: Polarizing filters can reduce reflections caused by water, which means they can help enhance the intensity of wet fall leaves.

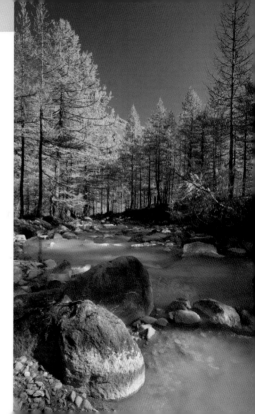

• TYPES OF POLARIZING FILTER

There are three main types of polarizing filter available, but the right one to choose will be determined by your camera.

Linear polarizer: *The most effective type of polarizer (and the least expensive), a linear polarizer also creates problems with auto focus and through-the-lens metering systems, to the point that neither will work effectively. Only useful if you own a fully manual (film) camera.*

Circular polarizer: *Polarizes the light in a different way to a linear polarizer, which retains the functionality of your camera's AF and metering systems. More expensive, but the only option if you're going to be using it on a digital SLR.*

Combined Polarizers: *Some polarizing filters combine the polarizing effect with another effect, such as warming the image or adding neutral density. Singh-Ray's Vari-N-Duo, for example, combines a variable-strength neutral density filter with a polarizer for added versatility in your shooting.*

RIGHT: A polarizing filter reduces the amount of light entering the camera, so it can also be used to increase exposure times. This can be useful if you want to use a long exposure to blur water, for example.

Neutral Density filters

Neutral density, or ND filters, have long been used by landscape photographers to control the amount of light entering the camera, or balance the brightness of the land and the sky. Put simply, a plain ND filter has a semi-opaque coating that physically reduces the amount of light coming through the lens by a fixed amount. Because the coating is neutral, the colors in a scene are unaffected (or should be), so the only impact the filter has is on the exposure.

The strength of an ND filter is measured in stops—typically full stops from 1 to 3, or higher—which determines the effect it has on the exposure. Using a 2-stop ND filter, for example, the exposure increases by two stops. If you're shooting in any mode other than Manual, your camera's through-the-lens (TTL) exposure metering will

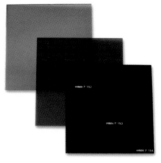

LEFT: ND filters are available as both slot-in filters and screw-in types, and come in a variety of strengths. Typically, a 0.3 ND reduces the light entering the camera by one stop, a 0.6 ND reduces it by two stops, and a 0.9 ND by three stops. Stronger ND filters are also available.

automatically take the filter into account, either by increasing the shutter speed, or by opening the aperture. This makes it important to use an exposure mode that's appropriate to the effect you want the filter to have: use Aperture Priority if you want the shutter speed to increase (to blur motion, for example), or Shutter Priority if you want the aperture to be affected (to get a shallower depth of field).

• HOW NEUTRAL IS NEUTRAL?

As there is a wide range of filter manufacturers and suppliers, it's hardly surprising that prices for ND filters vary wildly, which reflects the fact that not all ND filters are created equal: some are less neutral than others. For color-critical photography with slide film, it is important to bear this in mind, because a filter that isn't neutral (or very close to it) will introduce a permanent color cast into your images. This is slightly less of an issue if you're using negative film, as color adjustments can be made at the printing stage, and with digital photography, color changes are far easier to implement, either by fine-tuning your white balance or correcting your images in an editing program. However, a higher quality, neutral ND filter will save you the hassle.

RIGHT: A classic use of an ND filter is to extend the exposure time for water, to transform it into a blur.

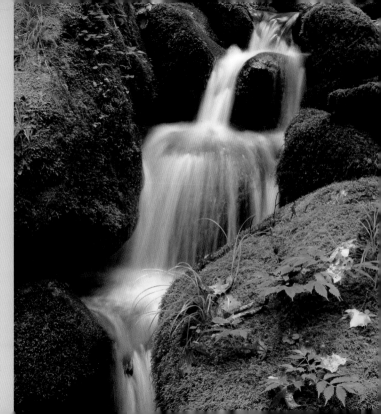

Graduated ND filters

As well as plain ND filters that affect the entire image, there are slot-in graduated ND filters (ND grads) that are used in a filter holder on the front of the lens to affect just part of the frame. These rectangular or square filters have a graduated neutral density coating that goes from full strength at one edge of the filter to clear at the opposite edge, with the "cut off" of the ND coating often at the center of the filter.

As with plain ND filters, ND grads are available in a variety of strengths and their main use in landscape photography is to balance a bright sky with darker land. By positioning the filter so the sky is affected by the ND coating, and the land is clear, the difference in the relative brightness of these two areas can be equalized, allowing more sky detail to be retained at the time of capture.

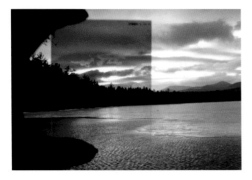

LEFT: A graduated ND filter is commonly used to balance a bright sky with a darker foreground. Holding the filter up to the scene shows a clear difference in the area of sky covered by the ND grad—there is more detail, and the highlights are less likely to burn out.

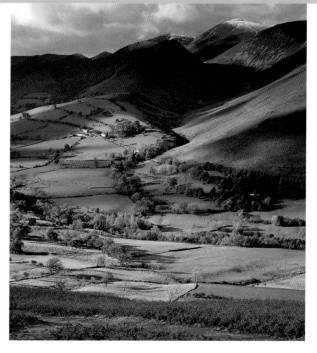

• ND GRADS: SOFT OR HARD?

Although the strength of the ND grad is one consideration, you will also have a choice of soft or hard. This refers to the transition from the clear part of the filter to the neutral density coating: a hard transition is more obviously defined, while a soft transition is more gradual. As a general rule, hard gradations are best used when the horizon is relatively even, such as when you're shooting a seascape, while a soft transition will work better when you have elements of the scene that break the horizon line, such as hills or buildings, for example.

SOFT ND GRAD

HARD ND GRAD

LEFT: Even when the sky isn't obviously bright, a graduated ND filter can be used to heighten the drama.

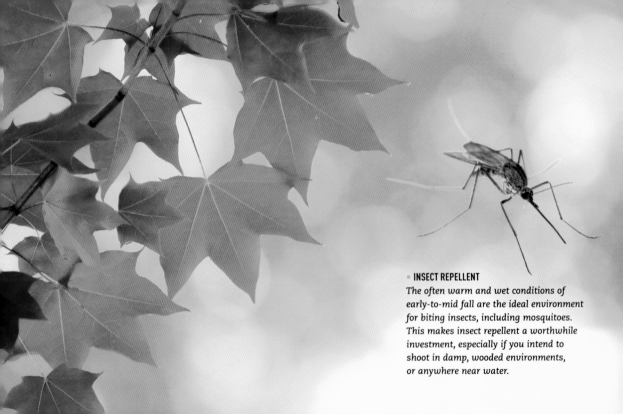

INSECT REPELLENT

The often warm and wet conditions of early-to-mid fall are the ideal environment for biting insects, including mosquitoes. This makes insect repellent a worthwhile investment, especially if you intend to shoot in damp, wooded environments, or anywhere near water.

 # CLOTHING

IN THE NORTHERN HEMISPHERE, early fall can bear many similarities to summer, as long, warm (or even hot) days continue to remind us of the sun's presence. At the end of fall, winter beckons, with plummeting temperatures, frosty mornings, and fewer daylight hours. Between these extremes, the weather can fluctuate: warm one day, cool and overcast the next, with rain always a possibility. With such disparate conditions, and the weather potentially changing on an hourly, as well as daily basis, you need to be prepared for these changes—there's nothing worse than having to abandon your shoot and head home just because a heavy rain shower passes through.

With this in mind, waterproof footwear is a must, and a lightweight waterproof jacket will ensure you have the option of staying dry if the weather turns, but without the bulk of a heavy coat. A jacket that can be stuffed into a pocket of your camera bag is ideal, and a camouflaged pattern (or at least a neutral, earthy color) is preferable to a bold, primary-colored jacket. This is simply because wildlife can be quite active during fall, and if you blend in with your surroundings this will improve your chances of getting close and including the wildlife in your landscape compositions. A military surplus store is a great place to find the sort of thing you're looking for.

LIGHT & WEATHER

SUNRISE & SUNSET

SUNRISE AND SUNSET ARE rightly known as the magic hours, with often-warm light and, at the start of the day, clear, pollution-free air that means greater visibility for your landscape photography. Perhaps more than any other season, the colors of fall respond best to shooting early or late in the day. We're not talking about the spectacular color of the sky at sunrise or sunset, or the long shadows at either end of the day that lend a landscape a greater three-dimensional appearance; instead, it is all about the warmth of the light—a warmth that naturally enhances the colors of the season. Of course, you can inject a little extra color into your shots using your image-editing software, so you might say that shooting at sunrise or sunset is unnecessary, but why spend time on your computer when nature is more than willing to do the job for you?

The ends of the day are the warmest of all in terms of color temperature, and it's this warmth that you want to exploit in your landscape shots. As with any digital photography, this means getting the white balance right, and asking your camera to automatically set the color temperature for you is a lazy answer—you need to take control for yourself. Under a clear sky or on a cloudy morning, this requires nothing more than switching your camera's white balance from auto to the appropriate preset to get the "correct" colors and retain the richness of your sunrise or sunset. But there are ways that you can go further still in the pursuit of accuracy, or perhaps to inject a little more warmth into your shots.

RIGHT:
Early-morning mist and the warm colors of a sunrise can combine to create a magic atmosphere for your landscape photographs.

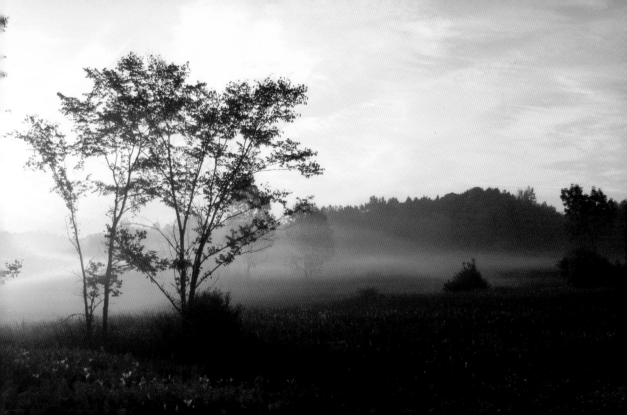

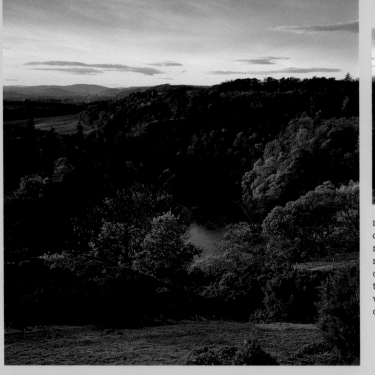

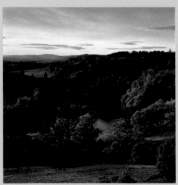

LEFT AND ABOVE: Set to Auto, your camera's white balance will attempt to neutralize any color bias, potentially removing the atmospheric warmth of dawn and dusk (above). Instead, use the daylight preset or set a custom white balance to retain the color (left), or even to enhance it.

Custom white balance

For the most accurate results, a custom white-balance can't be beaten. This is usually achieved by photographing a white or gray card under the same lighting conditions as your subject and telling the camera to use this as a reference for the white balance, but you can also use a white balance accessory that clips to the front of your lens in a similar fashion to a lens cap. The result will be the same, but a lens-based option will take up less space in your kit bag, as some double as a lens cap.

● **SHOOTING RAW**

The exception to getting the white balance right at the time of capture is if you shoot Raw images. The reason for this is because the white balance setting isn't embedded in the file, so you're free to alter it when you convert your Raw image into a TIFF or JPEG.

Warm white

As well as neutral white balance discs, some manufacturers produce slightly warmer versions. These are often marketed for portraits as they produce a custom white-balance setting with a warm bias that is good for adding a healthy glow to skin tones, but they can also be useful for landscapes where you want to exaggerate your fall colors.

An alternative (and cheaper) solution is to set the wrong white balance. For example, using a cloudy or shade preset on a sunny day will add a little more warmth to the shot, or your camera may allow you to manually adjust the color temperature. This won't be enough to make the picture look wrong, but it can enhance the already warm hues of dusk and dawn.

Side-lighting

The low angle of the sun at dusk and dawn often casts elongated shadows across the wider landscape, which is vital if you want to create a sense of three-dimensionality in your images, and the best time for creating exciting landscape photographs. As well as increasing the length of the shadows, the sunlight has to travel a much greater distance through the earth's atmosphere at either end of the day, which means that it is more heavily diffused by particles in the atmosphere (including pollution) than when the sun is overhead. As a result, the shadows that are cast are far less intense than they would be if the sun were higher in the sky, which means the contrast range can often fit within your camera sensor's dynamic range—assuming you aren't including the sun in your shot, of course.

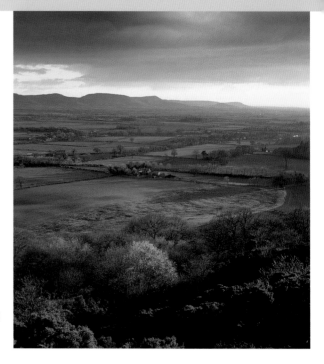

As well as allowing you to produce great images of a sweeping vista, side-lighting also works well on a more localized scale, throwing dramatic shafts of lights through woodland, for example, or adding definition to smaller subjects such as mushrooms and toadstools.

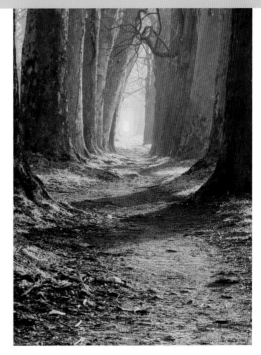

LEFT: In this example, the light is coming from the right, and slightly toward the camera. As the sun is low in the sky, shadows are quite long, helping to define the contours of the landscape.

RIGHT: Side-lighting works equally well for the closer landscape, as well as distant views. Here, for example, the shadows from the tree trunks add another level of interest as our eye travels toward the light.

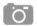

Silhouettes

With the sun low in the sky, sunrise and sunset are also ideal times to think about shooting silhouettes. The most obvious example in fall is toward the end of the season when the trees are bare, using the black of the tree to provide interest and seasonal context to a picture that is otherwise all about the color of the sky. This means you need to position yourself carefully so your subject is against the bright sky, which can sometimes mean including the sun in the frame. If you do have the sun in shot, then composing the photograph so the sun is behind the tree's trunk will avoid a hot spot in the image, and potentially add a dramatic halo of light. Alternatively, compose your shot so you're shooting toward the light, but with

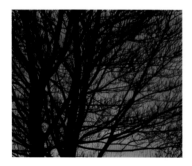

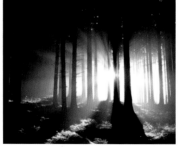

FAR LEFT: A classic fall silhouette that sets the solid black branches of the tree against a fiery sunset.

LEFT: Less obvious, but very dramatic silhouettes can be created as the early-morning sun floods a dark forest interior, especially if there is a light mist also.

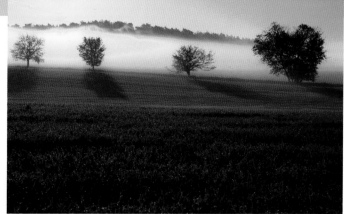

RIGHT: The key to exposing for a backlit silhouette is to take a spotmeter reading from the bright sky, rather than the darker foreground.

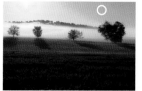

the sun just out of frame, remembering to shield your lens with a lens hood or your hand to minimize the risk of flare.

When it comes to gauging the exposure, this needs to be based on the sky and not influenced by the dark, silhouetted tree. So, rather than use your camera's multizone metering pattern, switch to centerweighted metering and take an exposure reading from the sky itself. Reframe the shot to include your subject, and set the aperture and shutter speed manually to ensure that the sky is correctly exposed and the subject is dark in the frame. If not, assess the histogram to see where you've gone wrong (see page 22–27, Winter), adjust your camera settings, and shoot again.

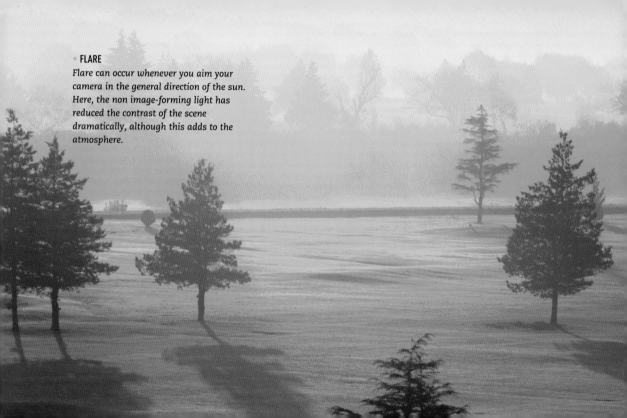

• FLARE
Flare can occur whenever you aim your camera in the general direction of the sun. Here, the non image-forming light has reduced the contrast of the scene dramatically, although this adds to the atmosphere.

Flare

Whenever you're shooting with the sun in the frame (or close to the edge of the frame), there is always a risk of introducing flare into your shots. Flare is caused by non image-forming light that is reflected by and

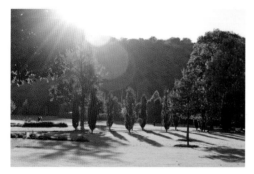

ABOVE: The series of colored artifacts emanating from the sun is a classic example of lens flare, and one that is hard to avoid if the sun is in shot.

from the glass elements in your lens, and there are two possible consequences: a series of colored shapes or artifacts appearing to emanate from the light source across the frame, or a simple reduction in contrast across the entire frame.

To prevent this, always ensure that you have the correct lens hood fitted to your lens, or at the very least, shade the front of the lens from the sun using your hand, a piece of card, or indeed anything else that can be used as an impromptu shade. Hiding the sun behind the subject you are photographing can also help reduce the effects of flare, but don't forget that flare can also be used to enhance the atmosphere in a shot—if you have the option, take photographs both with and without flare so you have a choice.

FROST

THE SURE SIGN THAT FALL is with us and winter is on its way is the arrival of frost, caused when moisture in the air freezes on contact with a cold surface. Frost is closely associated with early-morning photography, especially after a cloudless night has allowed the heat from the previous day to dissipate, leaving the ground hard and frozen. From a photographic standpoint, frost changes the mood of a landscape considerably, giving it anything from a light white dusting to a heavier, snow-like appearance. As the frost reflects more light, your in-camera meter may err on the side of underexposure if left to its own devices, so keep an eye on the histogram and be prepared to increase the exposure: applying +½–1 stop of exposure compensation is usually sufficient.

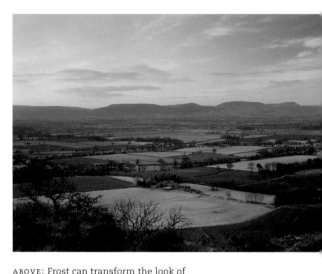

ABOVE: Frost can transform the look of a landscape, but in lightening the land it can occasionally fool a camera's exposure meter in a similar, but less extreme, way to snow.

Types of frost

There are a number of specific types of frost, each of which has its own unique causes and characteristics:

- **Hoar frost:** Hoar frost forms when water vapor comes into contact with cold surfaces such as plants and soil, and freezes on them instantly. This is the most common type of fall frost.
- **Window frost:** Window frost occurs when water droplets freeze on glass that is exposed to cold air on one side, and moist air on the other. This often creates a pattern similar to the leaves of a fern (it is also known as "fern frost"), which can make a great close-up study.
- **Rime frost:** In extreme weather, icy winds blowing across already-wet surfaces can result in rime frost. Forming far quicker than other frosts, it is not common in fall unless conditions are exceptionally cold.

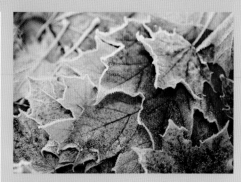

FROSTED DETAILS

Although frost has the ability to transform the wider landscape, don't forget to look for smaller details: heavily frosted leaves on the ground, or backlit fern frost on a window, for example. Although slightly removed from landscape photography, these detail shots shouldn't be overlooked, so as well as your regular landscape kit consider packing a macro lens for your morning photographic excursions.

MIST & FOG

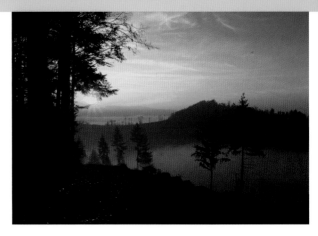

AS WELL AS THE risk of encountering heavy frosts in fall, the start of the day can often bring mist and fog, especially in low-lying areas close to water. Like frost, the cause of mist and fog is due to the temperature and the level of moisture in the air: when the air temperature drops to a point that it can't hold water as a vapor (known as the "dew point"), that water becomes liquid and creates what is effectively a cloud. This can happen at ground level, often creating a low-lying mist over fields, around rivers, lakes, or the sea, which commonly results in thicker fog, and is particularly noticeable in valleys as the moisture in the air sinks down.

For photographers, mist and fog can be a help or a hindrance, depending on what it is you are looking to achieve and where you are photographing from. If you're shooting from a high vantage point, looking down over mist-shrouded valleys below, for example, then pockets of fog can add an extra layer of interest to the image that may be welcome. Similarly, shooting a distant range of hills or mountains that are partially concealed by mist can strip these

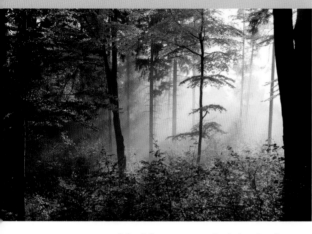

FAR LEFT: A light mist can add a hazy mystery to distant landscapes, especially around water.

LEFT: Damp woodland is prone to early-morning mist, and with the addition of strong, directional sunlight this could be the perfect recipe for magical images.

geographical features to their basic shape, concealing unwanted detail and leaving a stark, graphic impression of the outline of the landscape.

However, move to ground level and mist and fog may not be quite so welcome. While a low-lying mist may help add a sense of mystery to a dawn landscape, a thick fog can easily obscure everything in front of you, reducing visibility to the point that photography is almost impossible. But note that I say almost impossible—no matter how thick the fog, you will always be able to see something. Sure, you might not be able to photograph a sweeping vista, but there are details in the landscape that

• MIST AND FOG: WHAT'S THE DIFFERENCE?

Although mist and fog are both caused by moisture in the air, there is a distinction between them, with fog being the thicker of the two. The basic rule is that if the visibility is less than 1 kilometer (approximately 1100 yards) then you're in fog, but if you can see further than that, it's mist.

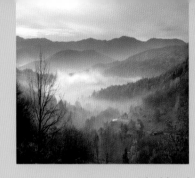 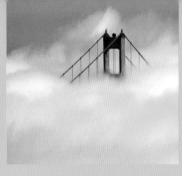

ABOVE AND ABOVE RIGHT: Mist (above) and fog (above right). The difference is in the density.

can be photographed instead: a stone wall that retreats and fades into the fog, for example, or semi-distant trees that have been reduced to a low-contrast near-silhouette by the damp in the air.

The first thing to realize is that you will need to get closer to your subject to ensure that it can be read in the final picture: the actual distance will be determined largely by the density of the mist or fog. Even when you get close, the landscape may still be reduced down to a minimal, ethereal world of looming, indistinct shapes, so look at it as an exercise in creating mood rather than recording detail. With this in mind, pay careful attention to the focal length you use: a longer focal length will allow you to stand further back from your subject, increasing the diffusion caused by the mist, while getting closer with a wide-angle focal length will help keep things slightly more distinct.

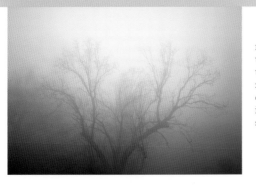

LEFT: Unlike mist, a thick fog can reduce the visibility to almost zero. However, even in challenging conditions it is still possible to create striking photographs.

In both instances, subjects that have a readily identifiable shape work better than those that rely on detail to tell the viewer what they are—a bare tree is more easily interpreted in mist than a bushy shrub, for example—and also consider working in monochrome. With its ability to effectively desaturate the landscape and leave it near gray, mist and fog are natural candidates for a black-and-white treatment, or the wrong white balance for creative effect.

• EXPOSURE TIMES

The water droplets that form the basis of mist and fog heavily diffuse the light above them, meaning that any subject you photograph in these conditions will be weakly lit. At the same time, the individual droplets do a great job of reflecting light and, as when photographing a heavy frost or snow, this can mean that your camera's exposure metering system may be fooled into underexposure. To see if that's the case, assess your camera's histogram after you've taken your shot, and apply positive exposure compensation (if necessary) before retaking the shot.

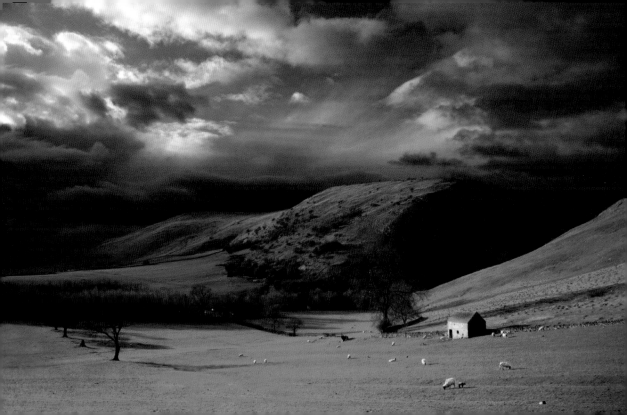

OVERCAST & WET

WHEN FALL ISN'T DELIVERING brilliant sunrises and balmy days, there's every possibility that it will be providing you with rain, or at least heavy gray skies. This is never great weather for photography, but it doesn't mean you have to abandon your camera altogether. As you'll see on the following pages, just because it's overcast or wet outdoors, that doesn't mean that you can't take some excellent photographs—you just need to change your expectations and seek out the most appropriate subjects.

LEFT: Changeable weather conditions can create dramatic skies, which can be emphasized even further with a graduated ND filter.

Contrast

Perhaps the most disappointing element of photography in overcast conditions is the flat light created by the thick clouds diffusing the sunlight above. The shadows that are vital for creating the impression of three dimensions in your photographs are often non-existent, leading to low-contrast and generally dull and lifeless images.

However, although the contrast is flattened in terms of brightness, when it comes to color this isn't necessarily the case: in fact, color contrast can be heightened as the warm fall colors are offset against drab surroundings, with the potential to create a stronger mood. With this in mind, think about looking for patches of color that contrast strongly with their surroundings, be it a bank of distant

trees whose leaves are ablaze with golden hues, or smaller details such as an individual fiery leaf set against a heavy gray sky—both have the potential to give you a striking shot on an otherwise mediocre day.

To increase the impact of your photographs, it's worth remembering that even if the colors appear lifeless at the time of shooting, you can boost the color contrast further by increasing the saturation in-camera or in your Raw

conversion or image-editing software. Regardless of when you do this, it's unlikely to affect the gray of the sky, or other desaturated colors, but may help give your fall foliage a little more punch. The same goes for the contrast, which can also be

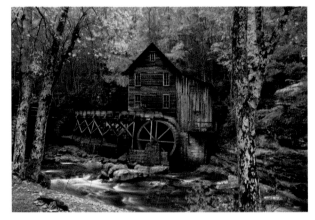

RIGHT: Some subjects, such as this mill, can actually benefit from being photographed on an overcast day when the contrast is lower. Harsh shadows could easily detract from, or obscure, the fine detail.

FAR RIGHT: When the sky is flat and gray, a simple solution is to exclude it from your fall landscapes, perhaps using a telephoto lens to fill the frame with color.

boosted through careful use of your camera or software, but if you want to be successful with either of these changes, you need to be sure that the colors are correct to start with. Increasing the saturation or contrast will only amplify the

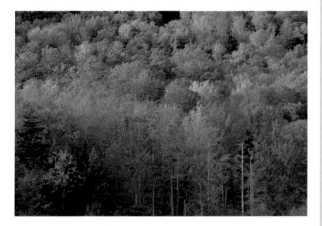

• WET-WEATHER DETAILS

The warm, damp weather that typifies fall is the perfect time for mushrooms and toadstools to grow, so don't just look for distant landscapes: get down low and look for fungi amongst the fallen leaves. As well as making an interesting subject in its own right (especially some of the more colorful specimens), fungus can also provide foreground interest in a broader landscape, especially if you use a wide-angle lens and a small aperture to maximize the depth of field.

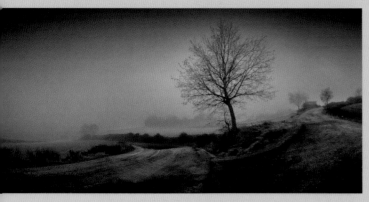

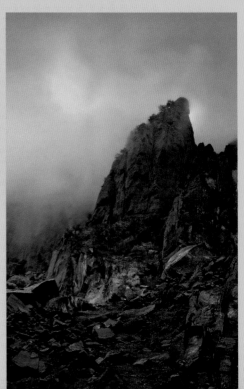

ABOVE AND RIGHT: As both of these shots demonstrate, picking out a small patch of color in a predominantly gray, rain-swept environment can lift an otherwise uninspiring and drab image.

colors that are already there, and if the white balance isn't set precisely, your adjustments will only make this more obvious. A custom white balance is again the best solution, although setting your camera to its cloudy setting will provide you with a good starting point.

Rain

When overcast skies turn to rain, landscape photography becomes a pretty uninspiring prospect, and rightly so—your camera can get wet, you can get wet, and the visibility (not to mention contrast) can decrease rapidly. Yet before the rain reaches you, the sky can be at its most dramatic. As thick, dark rainclouds roll in, they may be interspersed by shafts of light or fingers of God breaking through and beaming out across the landscape, or there might be a rainbow in the distance as the rain has already started falling further away. The same applies immediately after rain, as the clouds begin to break, so just because rain is predicted, don't let that prevent you from heading out with your camera, and don't let what could be a passing shower make you head for home. Unless you're sure the rain will stay, be prepared to sit it out and take advantage of the unique effect it has on the landscape.

• CAMERA PROTECTION

When it's raining, the last thing you want is to get wet, and it's the same for your camera—water and electronics just don't mix. A specialist rain cape for your camera is the ultimate wet-weather solution, covering your camera entirely to protect it from the elements, while providing you with a clear port at the front to shoot through, and easy access to your various controls. If you anticipate photographing wildlife, then a cape with a camouflage pattern will also break up your outline and help you photograph animals unnoticed.

EXPLOITING COLOR

CONTRAST

FALL IS A SEASON that is full of contrasts. Whether it's the conflicting weather as warm summer-like days become interspersed with the first chill bites of winter, or the juxtaposition of evergreen and deciduous trees as one retains its thick green foliage and the other is transformed into fiery hues, contrast can separate great fall photographs from lesser ones.

Perhaps the most powerful is the contrast of color. As anyone with a passing knowledge of color theory will appreciate, hues that oppose each other on the color wheel are complementary, so red is complemented by green, and orange by blue, meaning these particular color combinations work very well together. Conveniently, when it comes to taking photographs in fall these are the exact juxtapositions of color that appear naturally in the world around us, as warm orange-red leaves are offset against evergreen trees, still-lush grass, and blue skies. So, rather than fill the viewfinder purely with the hot colors of fall, look for color contrast, whether it's a close-up of a golden leaf against a blue sky, or a rogue orange-leaved tree in a forest of evergreens.

RIGHT: You don't need an in-depth knowledge of color theory to exploit contrast in fall: the warm oranges and reds that typify the colors of fall foliage sit opposite the cooler blues and greens of grass and the sky. These naturally complement each other and heighten color contrast.

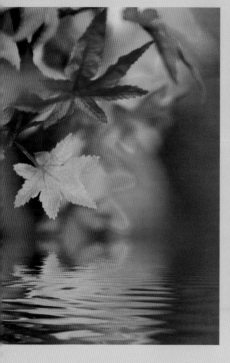

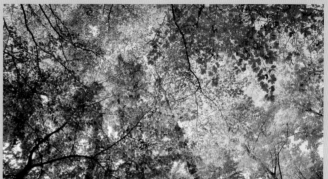

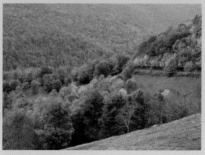

TOP, ABOVE LEFT, AND
LEFT: Putting theory
into practice:
complementary colors
form naturally striking
color combinations.
These are found widely
in the natural world
during fall, both as
close-up details and in
the broader landscape.

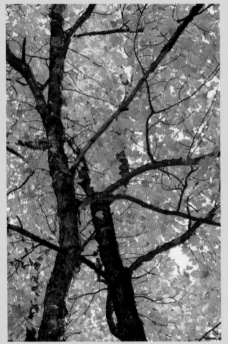

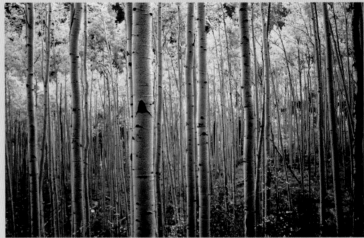

ABOVE AND LEFT: Contrast doesn't just have to rely on complementary colors. In these examples, contrast also comes from differences in form: the rigid trunks and branches compared to the random patterns of the leaves.

Alternative contrasts

Although the contrasting colors of fall are perhaps the most obvious and attractive elements to look out for in your fall photography, it only tells part of the story of the season and certainly isn't the sole reason why you should set up your tripod and take the lenscap off your camera. Toward the end of the season, when the majority—if not all—of the golden leaves on deciduous trees have fallen, there is a new contrast: the contrast of bare trees against still-green fields, or a lone evergreen that stubbornly refuses to shed its foliage, no matter what time of year it is.

This is the time to seek out specific tree species, such as the Paper Birch (also known as the White Birch) or the European Silver Birch, whose light-colored trunks will stand out starkly from the landscape. Grouped together, and photographed through a telephoto lens, the bright pillars created by the trunks can be isolated against a single-color background, creating stark, graphic photographs that contrast light and dark, rather than color. They look great in black and white, too.

There are other less obvious contrasts in fall, such as the contrast between the regular furrows of a freshly ploughed (brown) field lined by the apparently chaotic entanglement of a forest's boughs and branches, or perhaps nothing more than a field that has yet to be prepared for the new season—the simple contrast of a smooth, green field and a textured, earthy one seen through a telephoto lens can create a natural, calming abstract that still says much about fall.

ABSTRACT COLOR

THE COMPLEMENTARY COLORS OF fall are perfect for creating beautiful abstract images, where color, rather than an identifiable subject, becomes the main component of the shot. Whether you use a slow shutter speed to blur leaves as they move in a strong breeze against a deep blue sky (perhaps using a polarizing filter to enrich the colors even further), look to pick out color details, or even pan or rotate the camera during a long exposure, the impressionistic results you can achieve can create an equally compelling celebration of the season as a static shot.

Long exposures

On a windy day, using a slow shutter speed can transform the waving boughs of trees into a blur of color that stands out starkly from the static world around it. You will need to have your camera tripod-mounted for this (to avoid camera shake), but the process is straightforward. Start by setting the lowest ISO setting on your camera (such as ISO 100) and switch your camera to Aperture Priority. Set the smallest possible aperture (f/22, for example), and the combination of a low ISO and small aperture will naturally make the camera select the slowest possible shutter speed to maintain the exposure. If this is slower than ½ sec, then you are fairly certain to see movement in the leaves during the exposure, resulting in a gentle blur. If the shutter speed is faster than this, or you're working in a light breeze, consider fitting a neutral density filter or a polarizing filter to your lens to extend the exposure time.

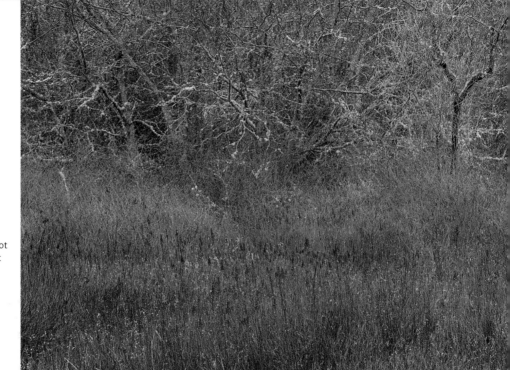

RIGHT: It is hard (but not impossible) to tell what the subject is in this abstract photograph, but it's the broad bands of color that are important here, not what is being shot.

Water

Moving water is a popular subject for landscape photography, so it's perhaps unsurprising that there's a lot of debate about how it should be done. On one side are people who insist that water should be frozen, so every drop can be identified in the image, while on the other side there are those who argue that as water is a fluid, ever-changing entity it should be recorded as a silky blur. Searching the Internet, you will discover proponents from both sides who are so zealous in their belief, that they will only accept there is one right way to photograph water. This is nonsense—photographing water is no different to shooting any other landscape subject, so personal preference is all that matters.

The result you get is determined by one thing—the shutter speed. Shutter Priority is the ideal mode to shoot in as you can set the duration of the exposure for the result you are looking for: a fast shutter speed will freeze water, while a slow shutter speed will emphasize its movement. Don't worry about the middle ground when it comes to the shutter speed. Instead, look

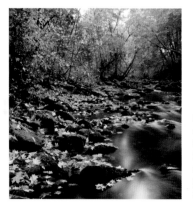

LEFT: Although taken on an overcast day, the color of the fallen leaves is still strong, making them the perfect counterpoint to this watery shot.

to the extremes, choosing ultra-fast or ultra-slow exposure times for maximum effect—1/500 sec or faster if you want every droplet to be pin-sharp, or 1 second or more for a dreamy blur. If you need to, shoot with a wider aperture and a higher ISO to increase the shutter speed, or drop the ISO right down and use your lens's smallest aperture setting for maximum blur. Adding a polarizing filter or a neutral-density filter will increase your exposure times further, but don't forget to use a tripod—water blurred through the creative use of shutter speed is very different to a water shot blurred due to camera shake!

RIGHT: Photographed with an ultra-slow shutter speed, the fast-moving water has been transformed into a mist-like blur. The red leaves mean there is little doubt as to the season, while the vibrant red hue contrasts with the cool (blue) surroundings.

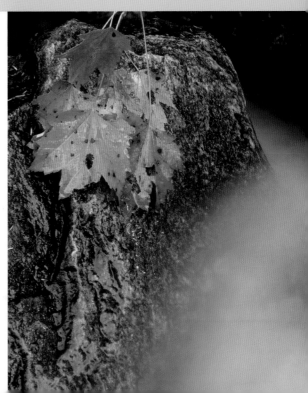

Reflections

While moving water can be treated in a variety of ways to create uniquely different images—even from the same vantage point—still water is not quite so dynamic. However, what it does have that water in motion does not, is a far greater capacity to act as a mirror, reflecting the land around it. Lakes, ponds, and even puddles have the potential to reflect the colors of fall, and this can be achieved in numerous ways.

The simplest option is to show the water in context, revealing the land around it so the viewer knows precisely what they are looking at: a body of water within the landscape that happens to be reflecting the fall colors. However, far more interesting results can be achieved when you can exclude the surrounding landscape and

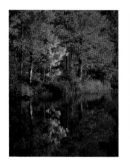

LEFT AND FAR LEFT: Cropping the original photograph so just the reflection remains, and then flipping the picture quickly creates a slightly distorted, abstract fall image.

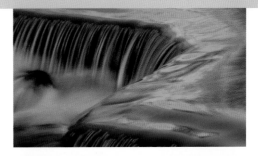

focus solely on photographing the reflections in the water. Without the context of the land, the viewer will have to work a little harder to read the image, which can mean longer spent studying a photograph, and greater reward when it is realized precisely what the image is of.

A classic treatment might be to photograph the reflection of fiery trees by the shore, and then invert the image so the upside-down reflection appears the right way up in the final print. In essence what you are creating is a visual illusion, where what appears at a glance to be a straight landscape view reveals distortion-producing ripples. Be sure to focus on the reflection, and not the surface of the water: reflections can easily confuse even the most sophisticated auto-focus systems, so you may need to switch to manual focus.

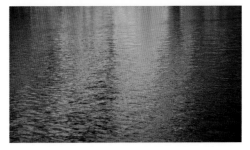

TOP AND ABOVE: These reflected images include the colors of fall to give them a seasonal context without the obvious inclusion of any trees in the frame.

Panning, tilting & rotating

Panning and rotating techniques are similar to using a long exposure, in that you want to start with a low ISO and small aperture setting to achieve a slow shutter speed—possibly by using filters over the lens as outlined previously. However, rather than keeping your camera still during the exposure, you will be moving it, so it isn't the movement of your subject that creates the blur, but the movement of your camera.

The easiest place to start is panning or tilting. Mount your camera on a tripod, but make sure that your tripod head is freed so that you can move the camera in one direction: either vertically to tilt it, or horizontally to pan across the frame. As a guide, panning works best when the colors of your subject are themselves in horizontal bands (panning across golden trees edging a green field, for example),

while tilting is most effective with naturally vertical subjects (such as tilting upward along tree trunks).

Regardless of the direction of movement you choose, trigger the shutter to start your

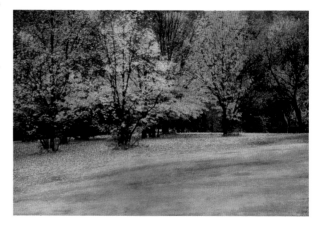

exposure and then physically turn (or tilt) the camera body for the duration of the exposure. The result should be a blur of expressive fall color, although there will be a certain amount of trial and error involved

in trying to get the speed of the camera movement to match the exposure time for the optimum result.

Alternatively, why not remove your camera from the tripod and, with a long exposure set, rotate it for a whirlpool-style result? Or simply move the camera around in a random fashion to blend your colors? You may well end up with nothing more than a muddy mess, but you could just as easily end up with an abstract masterpiece that celebrates the rich colors of fall!

LEFT AND OPPOSITE LEFT: Panning your camera during a long exposure can create bands of rich fall colors against a green field for a compelling celebration of the season. Rotating the camera can create similarly exciting, abstract results.

Software-based abstracts

Fall abstracts don't just need to be conceived at the time of capture—image-editing programs can also be used to creatively treat straight shots. The tools to experiment with are motion-blur filters (to emulate panning and tilting) and radial blurs (for rotated abstracts). You can also attempt to recreate long exposures by selectively blurring parts of the image—the options are endless.

The advantage of working in this way is that you can see the effect in an instant.

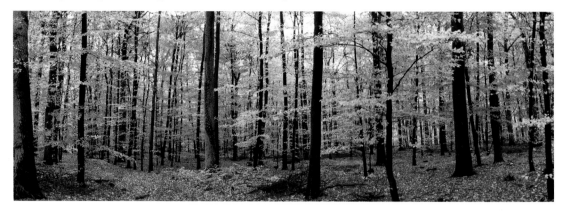

Everything is also reversible, so if you don't like the result you get from a particular filter you can simply remove it and try again until you get a result that you *are* pleased with.

BELOW AND OPPOSITE: Photoshop's Motion Blur filter was applied to this image with the Angle set to 90 degrees (vertical) and the Distance set to 250 pixels to create the abstract panorama shown below.

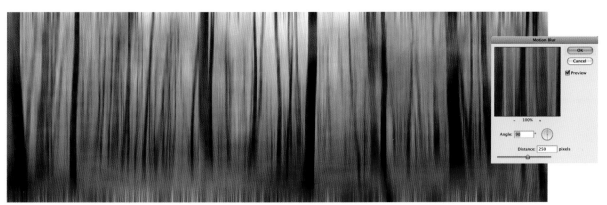

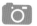 **INDEX**

PICTURE CREDITS

iStockphoto (www.istockphoto.com)/ John Brueske: p49 (bottom); Doxa: p49 (top); Duilio Fiorille: p10 (right); FotoTravel: p15; Gaspr13: p12 (top); Jpique: p44 (left); Ooyoo: p57 (bottom); Cole Vineyard: p14; Kerstin Waurick: p33.

Fotolia (www.fotolia.com)/ Georgios Alexandris: p11 (right); Arokas: p54; Kushnirov Avraham: p40; eAlisa: p44 (right); Joy Fera: p58; Gburba: p50 (left); Javarman: p20 (background); Joda: p37 and p30 (right); Stefan Körber: p49 (left);Henrik Larsson: p20 (right); Sainte-Laudy: p2–3; Carsten Meyer: p60, S. Mohr Photography: p31, Dean Pennala: p57 (top), Thierry Planche: p12 (bottom); Radu Razvan: p17; Reises: p36; Michael Shake: p42; .Shock: p29; Charles Taylor: p50 (right); Christy Thompson: p25; Fred Tinsel: p38 (left); A. Jess–TouTouke: p6; Vibe Images: p30 (left); Vicky: p11 (bottom right); Wilma: p43 (far right).

Photocase (www.photocase.com)/ Manuela Neukirch: p35.

Joe Cornish/Digital Vision: p5, p13, p28, p26, p34.

Chris Gatcum: p16.

Ben Frantz Dale: p18.

Expodisc (www.expoimaging.com): p11.

Equipment shots courtesy of Sony, Canon, Expodisc, Cokin, and Kata.

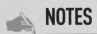 **NOTES**